This book belongs to:

DOODLING FOR
FASHIONISTAS

by Gemma Correll

www.walterfoster.com
6 Orchard Road, Suite 100
Lake Forest, CA 92630

Printed in China
1 3 5 7 10 9 8 6 4 2

TABLE OF CONTENTS

HOW TO USE THIS BOOK

Remember: This book is just a guide. Every artist has his or her own individual style. Using your imagination will only make the drawings more fun and special! The fun of doodling comes from not trying too hard. So don't worry about making mistakes or trying to make things "perfect."

Here are some tips to help you get the most of this doodling book.

DOODLE PROMPTS

The doodle prompts in this book are designed to get your creative juices flowing—and your pen and pencil moving! Don't think too much about the prompts; just start drawing and see where your imagination takes you.

STEP-BY-STEP EXERCISES

Following the step-by-step exercises is fun and easy! The red lines show you the next step. The black lines are the steps you've already completed.

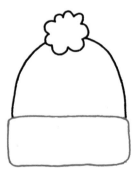

SUPPLIES

Doodling doesn't require any special tools or materials. You can draw with anything you like! Here are a few of my favorite drawing tools.

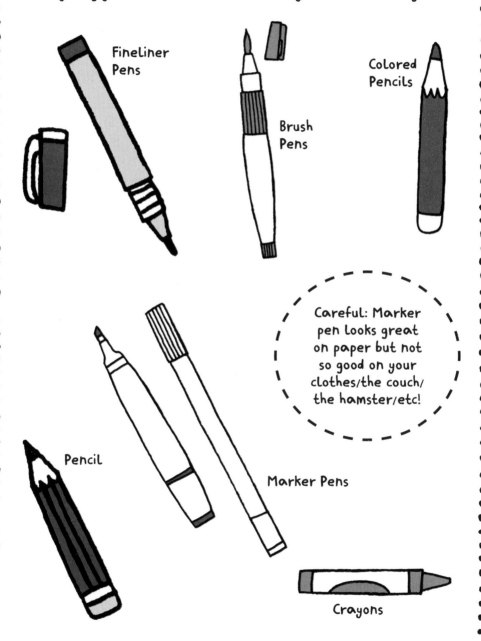

Fineliner Pens

Brush Pens

Colored Pencils

Careful: Marker pen looks great on paper but not so good on your clothes/the couch/the hamster/etc!

Pencil

Marker Pens

Crayons

20 SIGNS YOU'RE A FASHIONISTA

1. You plan every outfit a day in advance. Hey, that's just good time management.

2. Your tailor, dry cleaner, and cobbler are all on speed dial.

3. Your life dream is to design your own clothing line.

4. You're running out of closet space, and the kitchen cupboards are full of shoes!

5. The postal service needs a separate truck just to deliver your multiple magazine subscriptions.

6. Every sidewalk is your personal runway.

7. Your myriad accessories double as art in your room when you're not wearing them.

8. You eat nothing but cereal for a week straight so you can afford that new dress you simply MUST have.

9. You have more money invested in your handbag collection than in your pension.

10. You name your pets after designers. *Here, Gucci, Gucci, Gucci!*

11. You do a happy dance whenever you receive a gift card to your favorite store.

12. You never say "no" to an "emergency" shopping excursion with friends.

13. You believe that fashion is not whom you wear, but how you wear it.

14. Forget wallpaper...your walls are plastered in fabulously fashion-forward magazine photos.

15. Come rain, shine, or zombie apocalypse, you know how to rock a pair of heels.

16. You can properly pronounce Hermès, chambray, Givenchy, and haute couture.

17. You spend all your leisure time reading fashion blogs and magazines.

18. When you're having a bad day, a little window-shopping always cheers you up. It's called "retail therapy" for a reason!

19. The words "Dolce," "Gabbana," "Coco," and "Chanel" sound like poetry to your ears.

20. If the shoe fits, you buy at least three pairs.

DRAW OR PASTE A PICTURE OF YOUR FASHIONABLE SELF IN THE FRAME.

Your Fabulous Fashionista Self

Favorite place to shop:

Favorite article of clothing:

Favorite designer:

Favorite accessory:

Favorite fashion inspiration:

FASHIONISTA QUIZ

Can you match the terms below to their definitions?
Give it a try, and see how you do! Find the answers
at the bottom of page 11.

____1. Gauntlets

____2. Godet

____3. Bespoke

____4. Passé

____5. Kitten heel

____6. Haute couture

____7. Peplum

____8. Tea Length

____9. Ruching

____10. Dart

A. A short flared, gathered, or pleated piece of fabric attached at the waist of a jacket, dress, shirt, or skirt

B. A V-shaped tuck sewn into a garment to shape the fabric

C. Made to order

D. A short heel approximately 1.5" to 2" high with a curve

E. Gathers in fabric created by pulling it between two or more lines of stitching

F. Dress gloves that extend above the wrist

G. A dress hemmed at the bottom of the shin

H. A triangular piece of fabric (often rounded at the top) inserted into a garment for fullness

I. High fashion; literally means "finest dressmaking"

J. No longer in style

1: F 2: H 3: C 4: J 5: D 6: I 7: A 8: G 9: E 10: B

FASHION LOOKS
OUT AND ABOUT

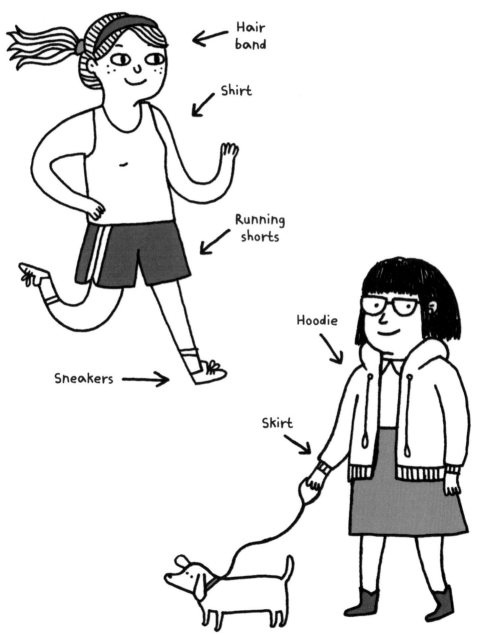

Hair band

Shirt

Running shorts

Hoodie

Sneakers

Skirt

AT HOME

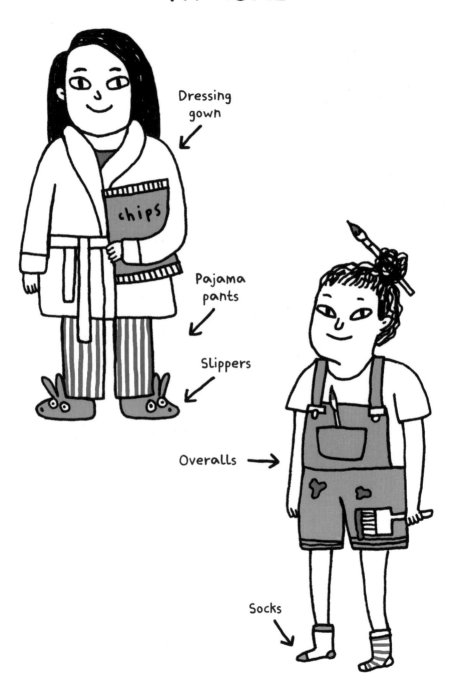

Dressing
gown

chips

Pajama
pants

Slippers

Overalls →

Socks

SUMMER OUTFITS

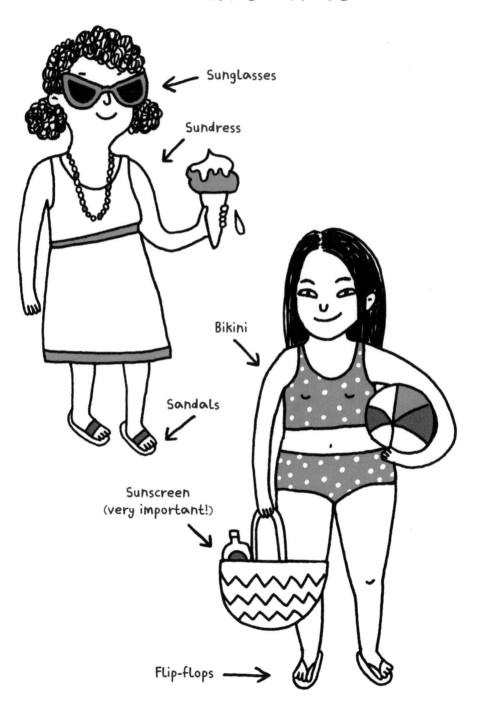

Sunglasses

Sundress

Bikini

Sandals

Sunscreen
(very important!)

Flip-flops

WINTER OUTFITS

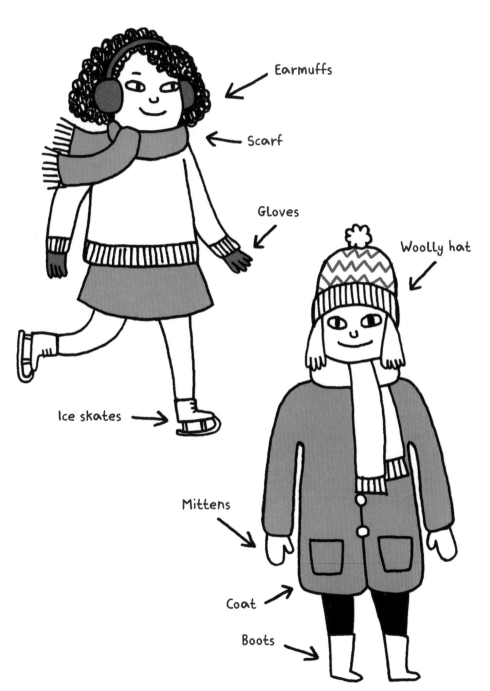

Earmuffs

Scarf

Gloves

Woolly hat

Ice skates

Mittens

Coat

Boots

SHOE LA-LA!
FLAT SHOES

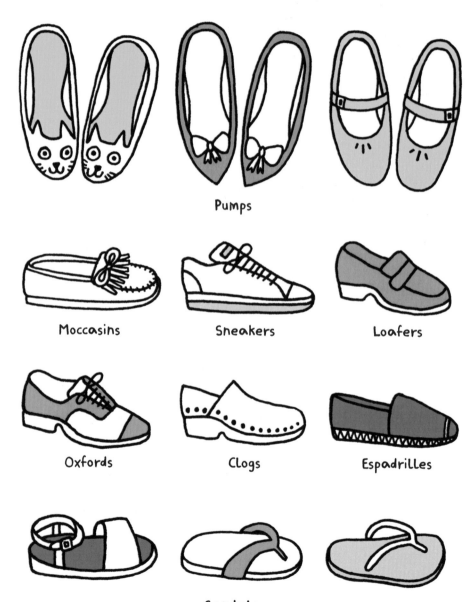

Pumps

Moccasins

Sneakers

Loafers

Oxfords

Clogs

Espadrilles

Sandals

HIGH HEELS

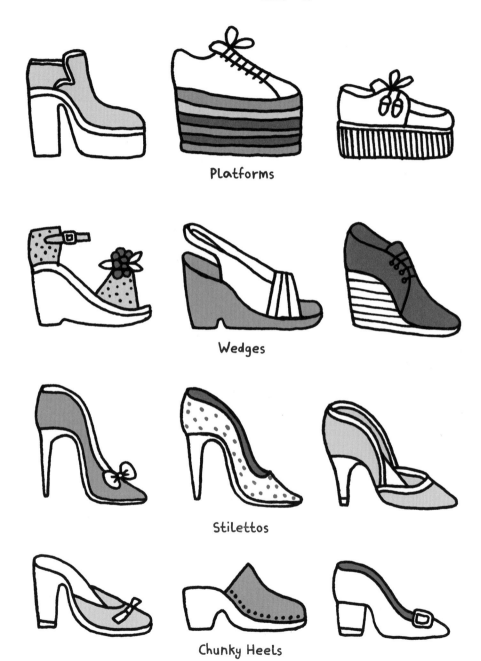

Platforms

Wedges

Stilettos

Chunky Heels

Adorn these plain shoes with patterns, color, and other fancy embellishments.

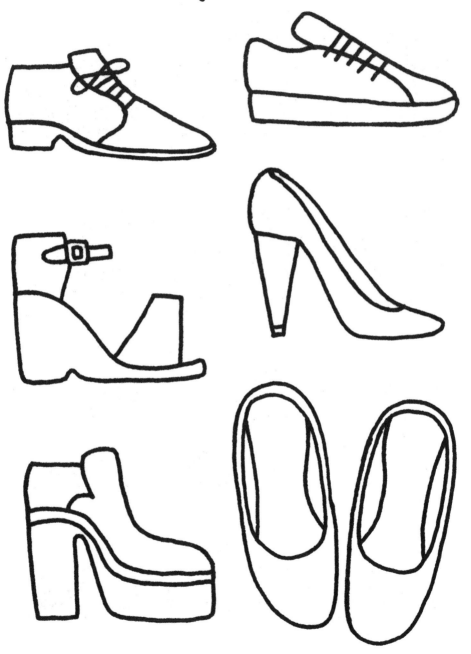

BEAUTIFUL BOOTS

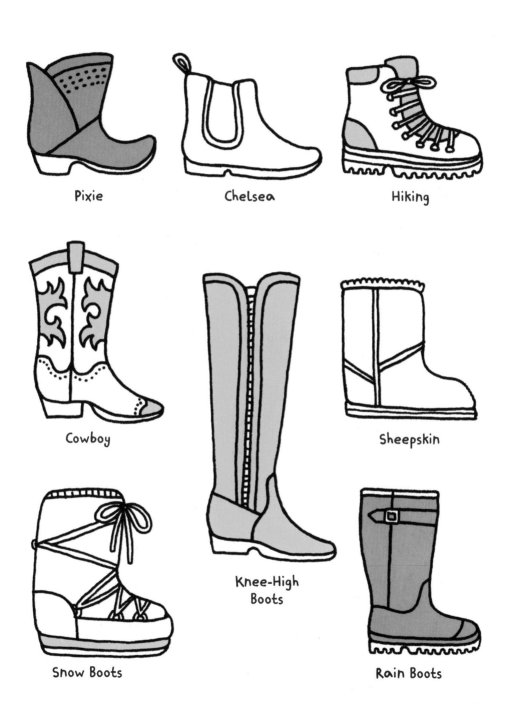

Pixie

Chelsea

Hiking

Cowboy

Knee-High
Boots

Sheepskin

Snow Boots

Rain Boots

DESIGN YOUR OWN COWBOY BOOT—YEE HA!

Cowboy boots come in all sorts of fun designs and patterns. Have a go at designing your own.

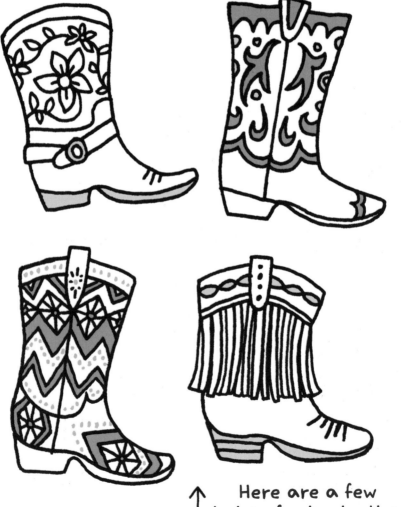

Here are a few designs for inspiration.

PURSES & BAGS
LITTLE BAGS AND PURSES

For just the essentials.

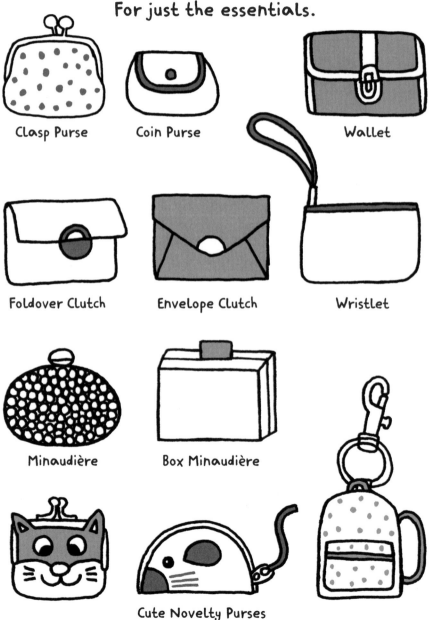

Clasp Purse

Coin Purse

Wallet

Foldover Clutch

Envelope Clutch

Wristlet

Minaudière

Box Minaudière

Cute Novelty Purses

HANDBAGS

In all shapes and sizes!

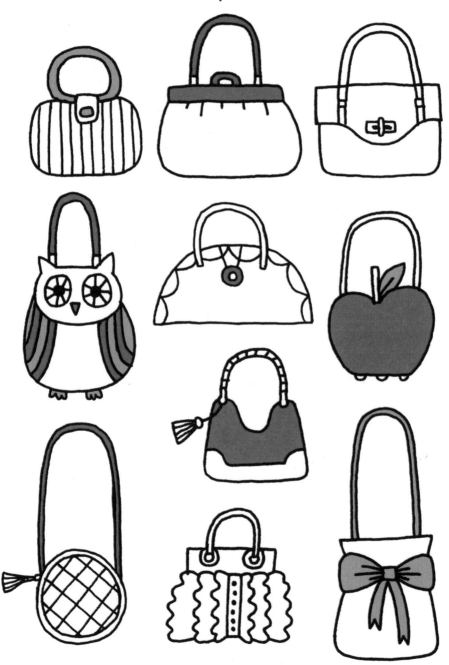

TOTE BAGS

As a conservative estimate, I would guess that I own approximately one million tote bags. How many do you have?

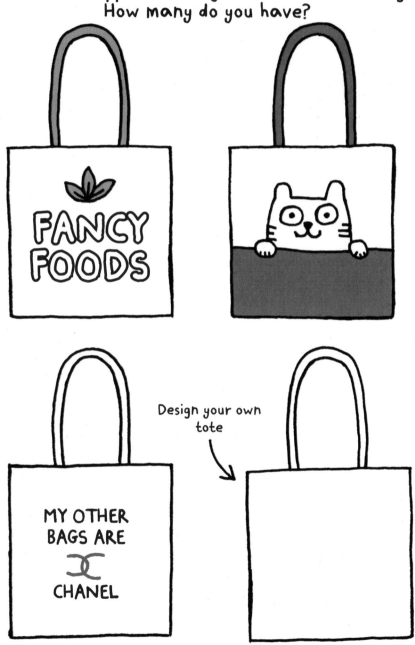

FANCY FOODS

MY OTHER BAGS ARE CHANEL

Design your own tote

BIG 'N' USEFUL BAGS

Got a lot of stuff to carry around? Then you'll need one of these large, useful bags.

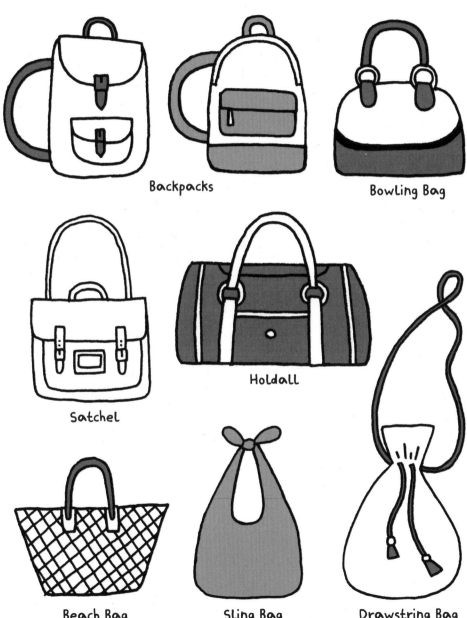

Backpacks

Bowling Bag

Satchel

Holdall

Beach Bag

Sling Bag

Drawstring Bag

WHAT'S IN MY BAG?

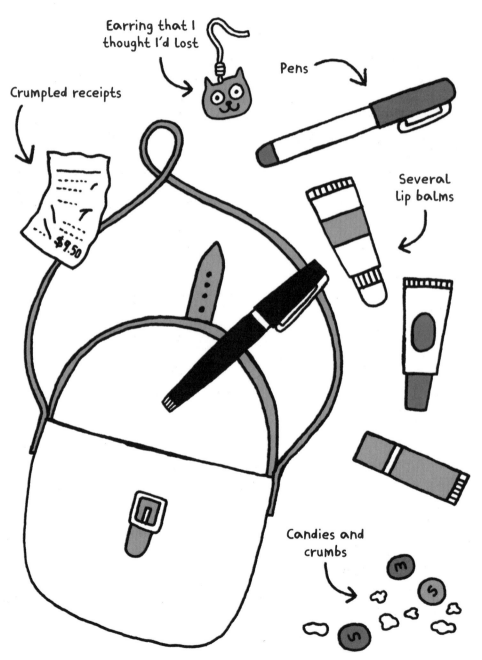

Earring that I thought I'd lost

Crumpled receipts

$9.50

Pens

Several lip balms

Candies and crumbs

WHAT'S IN YOUR BAG?

Draw your favorite bag and its contents here.

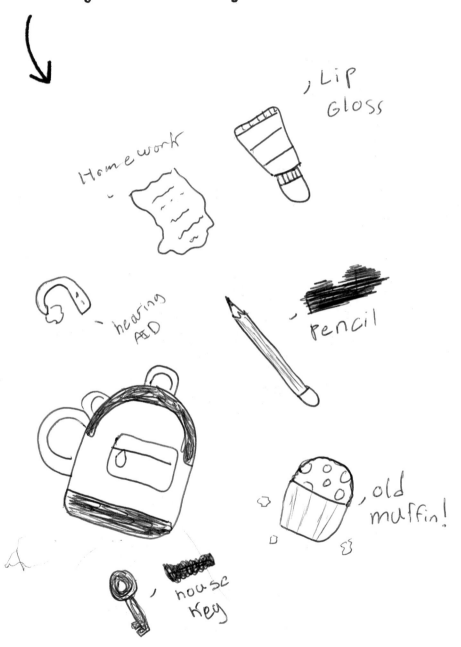

Lip Gloss

Homework

hearing AID

pencil

old muffin!

house Key

LOVELY LOCKS
LONG HAIRSTYLES

Straight
with Bangs

Wavy

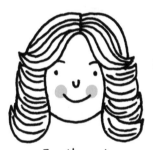

Feathered
(very 1970s!)

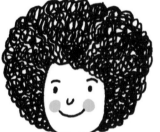

Afro

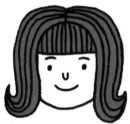

The Flip
(popular in the 1960s)

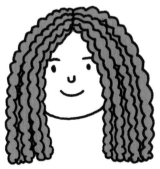

Dreadlocks

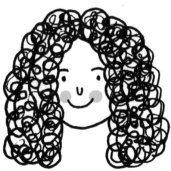

Curls

SHORT HAIRSTYLES

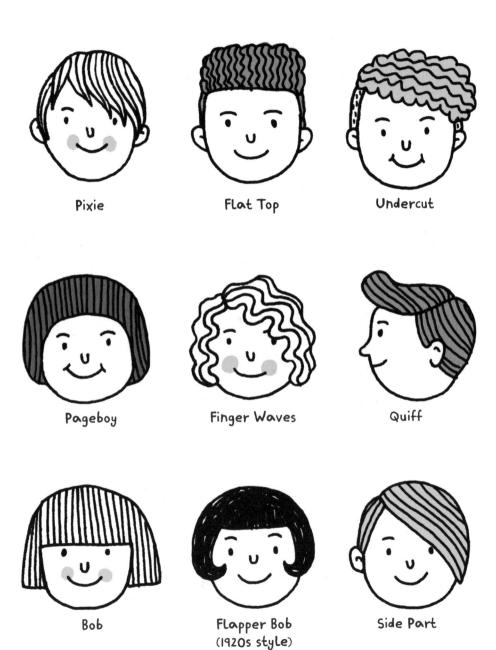

Pixie

Flat Top

Undercut

Pageboy

Finger Waves

Quiff

Bob

Flapper Bob
(1920s style)

Side Part

HAIR UP

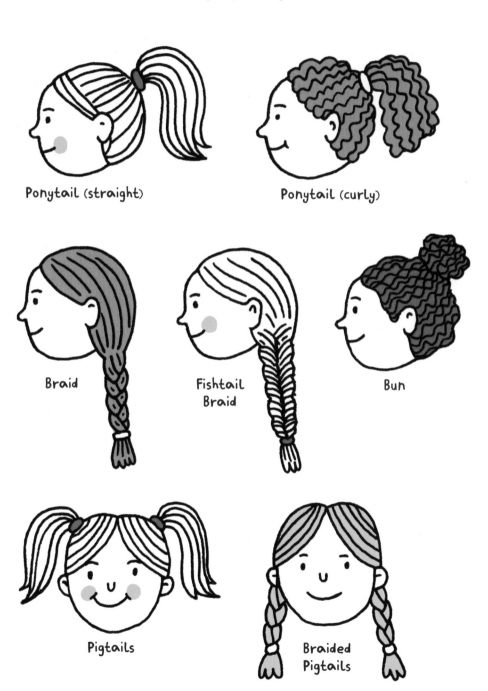

Ponytail (straight)

Ponytail (curly)

Braid

Fishtail
Braid

Bun

Pigtails

Braided
Pigtails

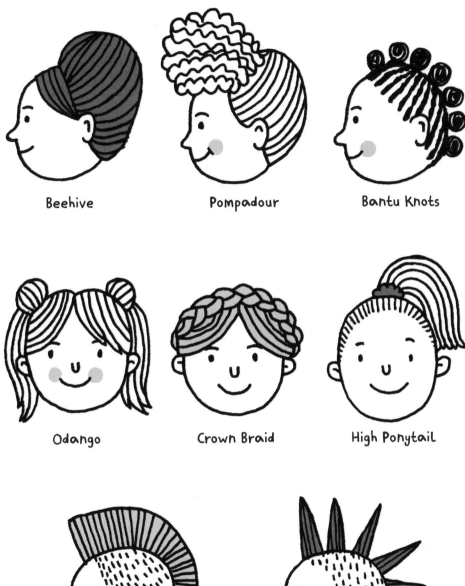

Beehive

Pompadour

Bantu Knots

Odango

Crown Braid

High Ponytail

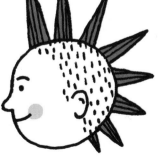

Mohawk

Liberty Spikes

LET'S ACCESSORIZE!

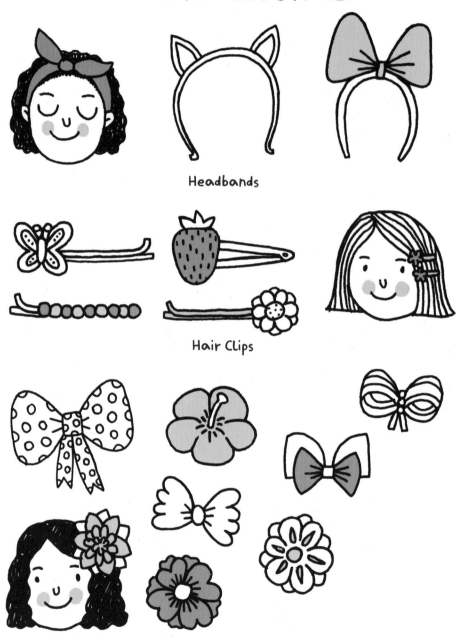

Headbands

Hair Clips

Flowers 'n' Bows
Add a few of your own!

Doodle a few hairstyles onto these bare heads.
(Don't forget to accessorize!)

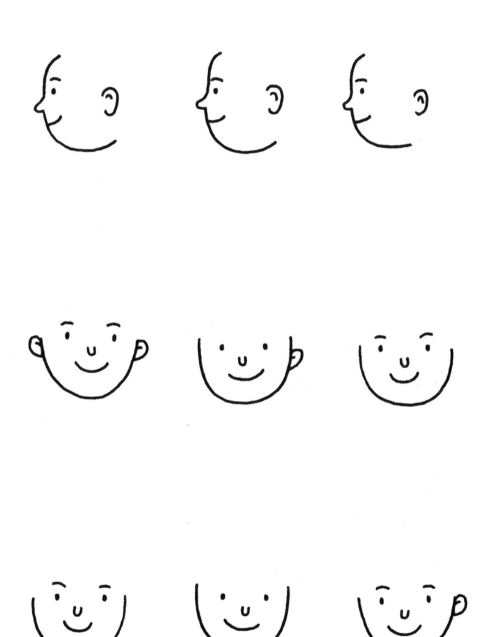

DRAW A SELF-PORTRAIT

The perfect way to get started in clever illustration is with a self-portrait. After all, what better model than your wonderful, fabulous self?

pens or pencils

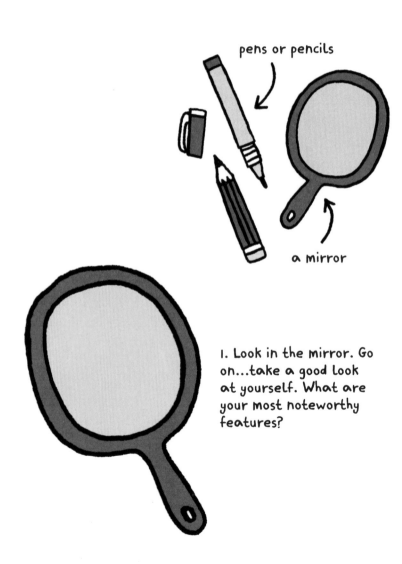

a mirror

1. Look in the mirror. Go on...take a good look at yourself. What are your most noteworthy features?

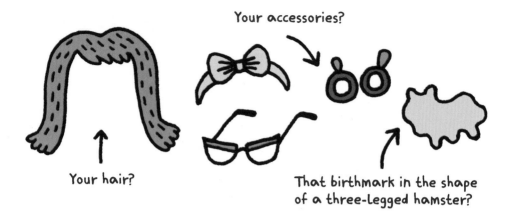

Your accessories?

Your hair?

That birthmark in the shape of a three-legged hamster?

2. You can draw a very basic face shape with two eyes, a nose, two ears, and a mouth... Y'know, all the usual things.*

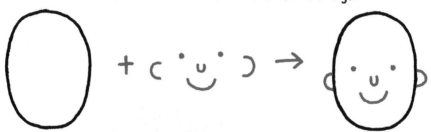

*Unless your noteworthy feature is your third ear. If it is, I'm really sorry and totally did not mean to offend you.

3. How are you feeling today? You can change the facial expression using just the mouth and eyebrows.

Here are a few examples.

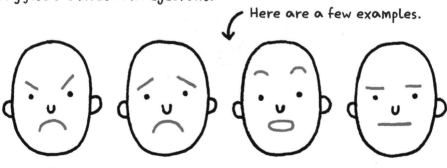

Look how simple it is to change the expressions using very basic lines. Try out a few different expressions.

4. Now add your noteworthy, extra-special, fantastic features to this basic face.

To make it look more like me, I'll add my glasses.

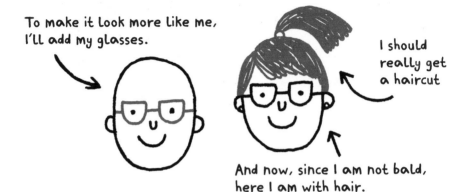

I should really get a haircut

And now, since I am not bald, here I am with hair.

5. Add some color, if you're into that kind of thing. I'm going to give myself some rosy cheeks, because I like to think of myself as some kind of cartoonist Snow White. (Except instead of dwarfs, I have pugs.)

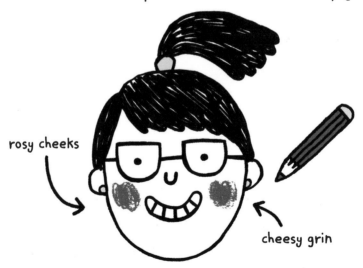

rosy cheeks

cheesy grin

Ta-da! Finished! Your very own self-portrait.

ARTIST TIP

Now that you've drawn your wonderful self, why not try drawing your friends and family?

Try using different materials or experiment with scale.

A hand-drawn, framed portrait makes a great gift!

Draw your self-portrait here!

milli
&
milan

sorry
messed
up

39

DRAW AN AWESOME UMBRELLA

1. Draw a straight(ish) vertical line.

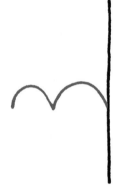

2. Draw two semicircles (or an "m" if you prefer!) about halfway down the line.

3. Draw two more semicircles on the other side.

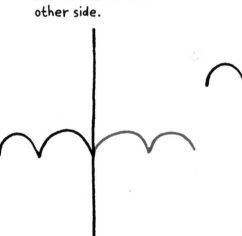

4. Add the handle.

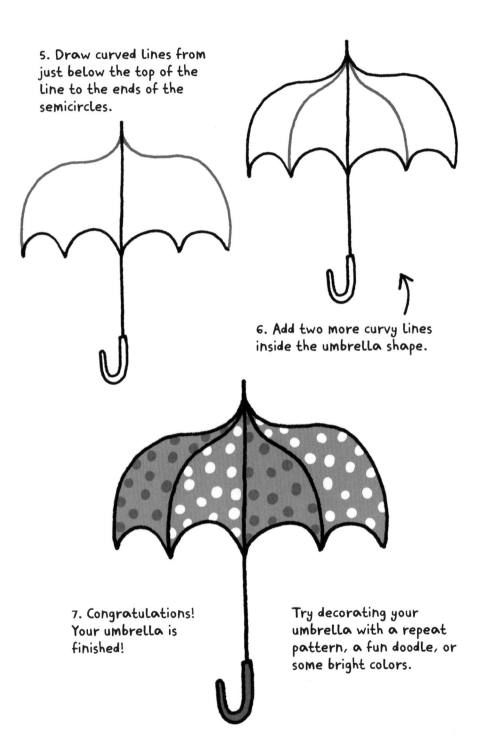

5. Draw curved lines from just below the top of the line to the ends of the semicircles.

6. Add two more curvy lines inside the umbrella shape.

7. Congratulations! Your umbrella is finished!

Try decorating your umbrella with a repeat pattern, a fun doodle, or some bright colors.

Draw your awesome umbrella here!

DRAW A SUPER SIMPLE SHIRT

1. Draw three sides of a rectangle, like this.

2. Draw this shape at the top, so that it looks like a teabag!

3. Then add two triangles to form the collar.

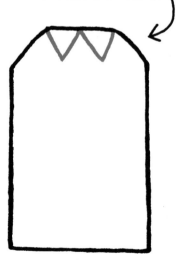

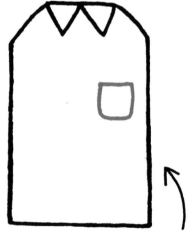

4. Draw a small pocket on the chest.

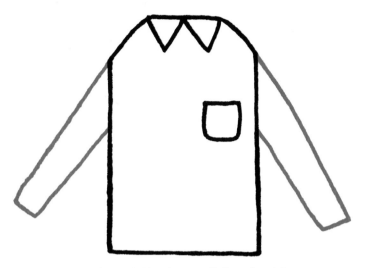

5. Starting at the base of the shoulders, draw the arms of the shirt.

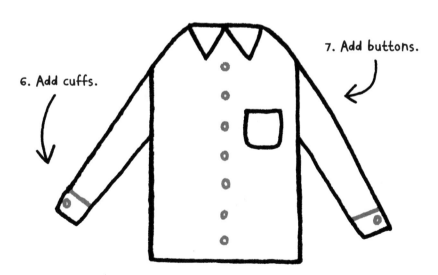

6. Add cuffs.

7. Add buttons.

Well done! You've finished drawing your shirt.

Draw your super shirt here!

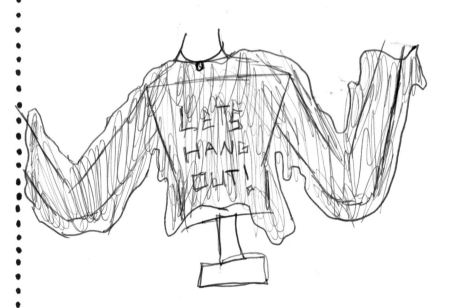

KNOW YOUR SHOES

Everybody knows their heels from their flats and their boots from their flip-flops. But you do know your monk from your mule? Or your brogue from your blucher? Check this handy-dandy guide to shoe types!

Blucher: A type of oxford in which the tongue and the front part of the shoe are cut in one piece

Brogue: An oxford-style shoe with a low heel and traditional wingtip design

Clog: A shoe (or sandal) with a thick, typically wooden, sole

Espadrille: Shoe with a canvas upper and rope sole; often with long shoelaces that tie around the ankle

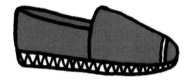

d'Orsay Shoe (or slipper): Any shoe that has a closed heel and toe but is cut down to the sole at the sides; named after the Count d'Orsay

Gladiator: Open-toed sandal that resembles the shoes worn by ancient Roman fighters

Jellies: Man-made shoes with a soft, rubbery material

Loafer: A moccasin-style, slip-on shoe with a slotted strap at the front, which is stitched into the front of the shoe

Louis Heels: Women's shoes with a curved, medium-high heel; also known as "French heels" or "pompadour heels"

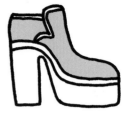

Mary Janes: A shoe style that features a buckled strap across the inset; traditionally flat and made of patent leather

Moccasin: A slip-on shoe with stitching around the toes, creating a gathered look

Monk: Characterized by a closed toe and a wide buckle across the tongue instead of laces

Mule: A closed-toe shoe with an open heel

Oxford: Basic shoe style that laces shut or is closed with another type of fastening

Platform: Footwear defined by a thick, exaggerated sole

Plimsoll: A light sports shoe made of strong cloth with a rubber bottom

Wedge: A heel that extends from the back to the ball of the shoe, laying flat on the ground

Wingtip: Features a toe cap that comes to a point in the center and spreads toward the sides of the shoes in a shape that resembles wings; the edges are sometimes perforated

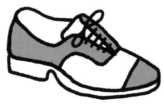

DRESSING UP
DRESSES

Circle

Strapless

Peplum

Ball Gown

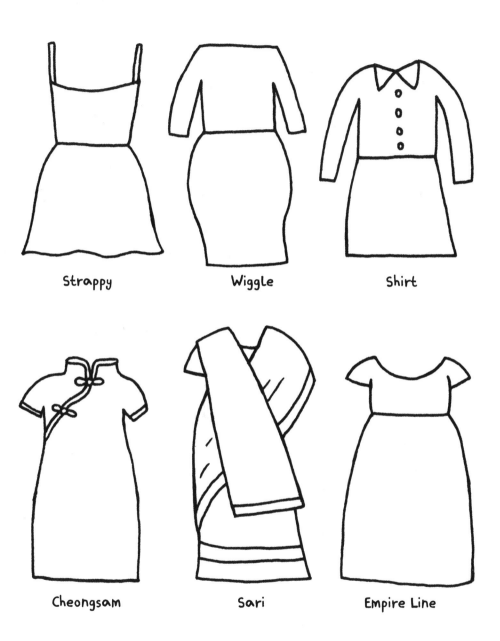

Strappy

Wiggle

Shirt

Cheongsam

Sari

Empire Line

SKIRTS

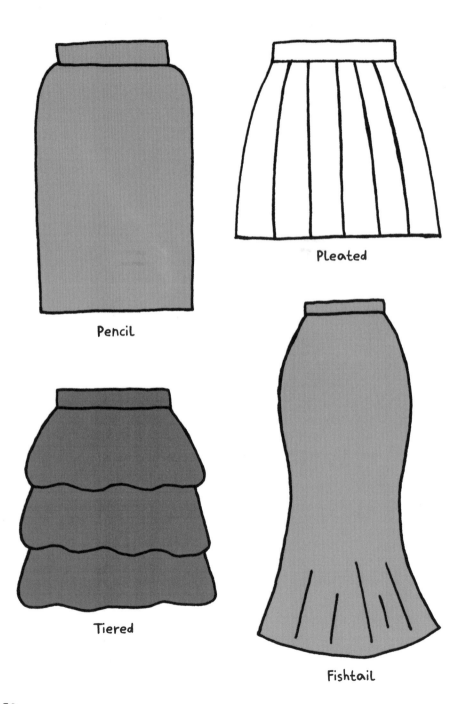

Pencil

Pleated

Tiered

Fishtail

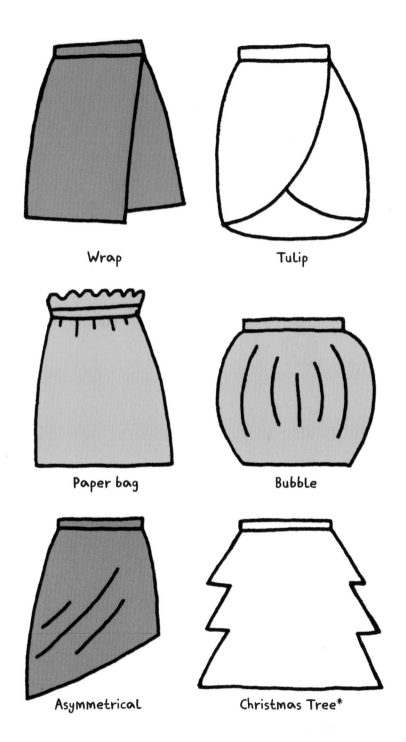

Wrap

Tulip

Paper bag

Bubble

Asymmetrical

Christmas Tree*

*OK, so I might have made this one up.

Embellish this fashionista's evening gown with fun patterns, textures, or designs.

Add some glamorous accessories too!

Doodle your dream gown here...

Doodle more fancy frocks here!

AWESOME ACCESSORIES

EARRINGS

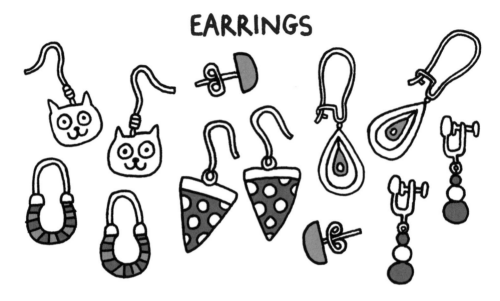

BROOCHES, BUTTONS, AND PATCHES

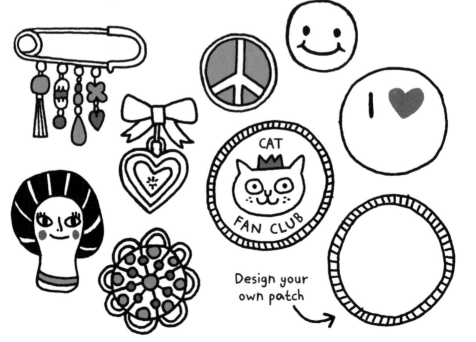

CAT FAN CLUB

I ♥

Design your own patch

BRACELETS

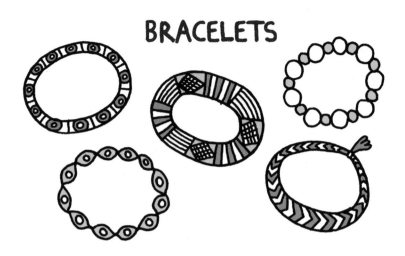

Charm bracelets were really popular in the 1950s and '60s. Girls collected souvenir charms from their vacations or received special charms as gifts from their family, friends, or sweethearts to add to their bracelets.

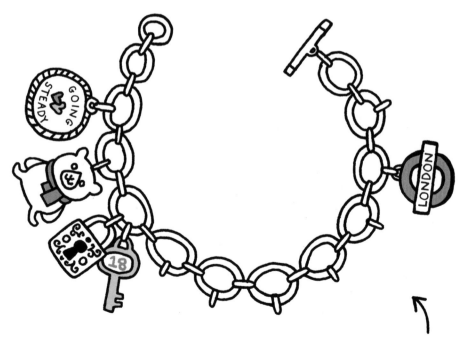

Add some more charms to this bracelet.

NECKLACES

Personalized Necklaces

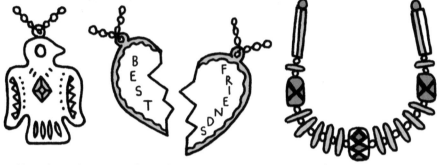

Native American Best Friends Pendants African Beads
Thunderbird Pendant

Lockets hold photographs of loved ones or small keepsakes. (Locks of hair were very popular in Victorian times!)

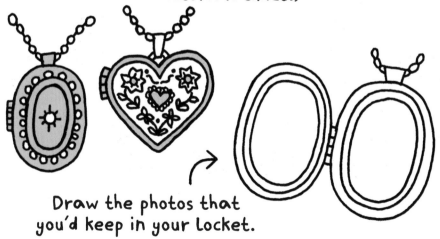

Draw the photos that
you'd keep in your locket.

RINGS 'N' THINGS

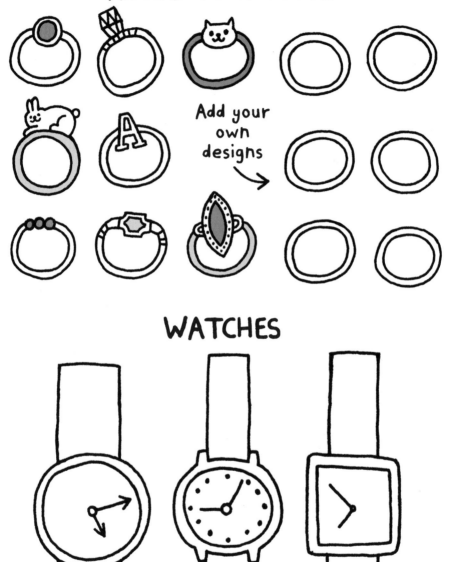

Add your own designs →

WATCHES

Decorate these timepieces to make them look awesome.

BEADS

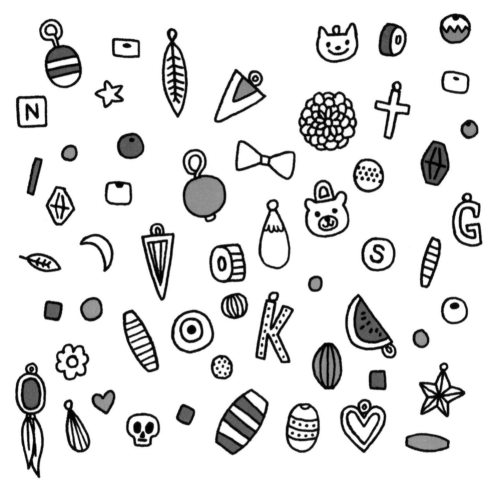

Doodle some of your own bead ideas below.

DESIGN YOUR OWN ACCESSORIES

Dream up some fun/wacky/cute/pretty/punky
(whatever you're into!) accessories.
Then doodle them below!

SHORTS & PANTS

Gym Shorts

Daisy Dukes
(cut-offs)

Cycling Shorts

Board Shorts

Culottes

Bloomers

Overalls

Playsuit

Two-Piece

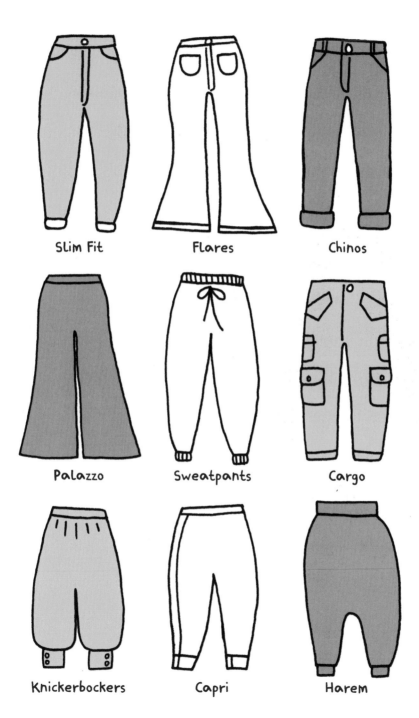

Slim Fit

Flares

Chinos

Palazzo

Sweatpants

Cargo

Knickerbockers

Capri

Harem

DESIGN A WONDERFUL, WARM ONESIE

Doodle a design for a cozy, fun onesie that you'd love to wear when you're lounging around the house.

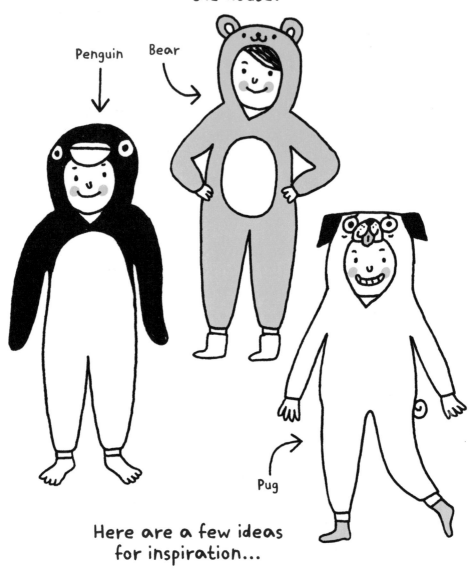

Penguin

Bear

Pug

Here are a few ideas for inspiration...

FUN FASHION FACTS

Fact: False eyelashes were invented in 1916 for a Hollywood movie producer who wanted to enhance an actress's eyelashes. A local wig maker made them out of human hair woven through fine gauze.

Fact: A "grabatologist" is a person who collects neckties.

Fact: During the Renaissance, it was considered in vogue for fashionistas to shave off their eyebrows.

Fact: According to Icelandic folklore, if you don't receive new clothes for Christmas, a giant Yule Cat will eat you up!

Fact: One of the earliest fashion magazines was published in 1586 in Germany.

Fact: The word "stiletto" comes from the Latin word that means "stake" or "small knife."

Fact: The world's longest wedding dress had a train that was 1.85 miles long, made of approximately three miles of taffeta and 18 feet of lace!

Fact: Men's shirts button on the right; women's shirts button on the left.

Fact: In medieval times, a person's social rank and profession was represented by the color of their clothing—nobility wore red; peasants wore brown and gray; and merchants, bankers, and gentry wore green!

Fact: The first Fashion Week took place in New York City in the early 1940s.

Fact: Up until the nineteenth century, designers used small dolls (instead of models) to showcase their designs to customers.

Fact: A typical Elizabethan noblewoman (or man) wore approximately 10 items of clothing or more at a time!

Fact: The word "crinoline" comes from the French word for horsehair. The first crinolines were quilted petticoats stuffed with horsehair.

Fact: Napoleon Bonaparte is the reason we have buttons on jacket sleeves today... the military commander ordered buttons to be attached to his soldiers' jacket sleeves to dissuade them from wiping their runny noses on the sleeves!

Fact: Umbrellas were initially invented to shield people from the sun, not rain.

WHAT ARE YOU WEARING?

What are you wearing right now? Pajamas? sweatpants? An evening dress? Doodle it here!

Now doodle what you will wear tomorrow...

DRAW A WONDERFULLY WARM WOOLLY HAT

1. Draw a bobble for the top of the hat.

2. Draw two curved lines—these will form the main part of the hat.

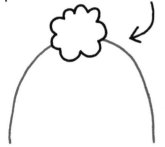

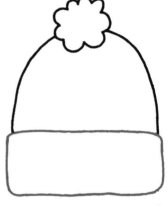

3. Draw a rectangle with curved edges at the bottom.

4. Add parallel vertical lines to the rectangle.

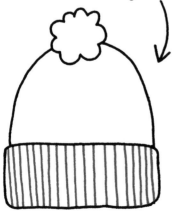

5. Add a little bit of texture to the bobble.

6. Finally, add some pattern to your hat.
Try out different line styles and shapes.

These hats are knitted, so the designs
are usually simple and graphic.

Draw your woolly hat here!

FASHION GLOSSARY

The world of fashion is full of fancy words and phrases...here's just a smattering!

Appliqué: A decorative design sewn onto a garment as embellishment or decoration; especially popular in couture

Batik: A hand-decorating technique for textiles in which part of the fabric is covered with wax, the fabric is dyed, and only the unwaxed areas absorb the dye

Boxy: Square in shape, with minimal tailoring; commonly seen on jackets

Cabochon: A gemstone or bead that has been convexly shaped and polished, instead of cut and faceted

Calendering: A special finishing process to make fabric appear more lustrous

Cap Sleeve: In between sleeveless and short sleeve; a flattering cut that elongates the arm and covers the shoulders

Culottes: Cropped, wide-leg pants that hang like a skirt

Dirndl Skirt: A full, wide skirt with a tight, fitted waistline

Dobby: A woven fabric characterized by a textured appearance and geometric patterns in the cloth

Epaulets: A decorative shoulder adornment; often found on military uniforms and trench coats

Faille: A slightly ribbed fabric with a crisp drape

Filigree: Decorative technique using fine wire (usually silver or gold) and tiny beads

Flocking: The application of raised fibers to a contrasting fabric to produce a decorative, textured print

Fourragère: Ornamental cords or chains worn over the shoulder in military-inspired dresses and blazers

Frog: A decorative closure on a garment that is made from cord or braid, consisting of a loop on one side and a large, decorative ornamental knot on the other

Gaiter: A piece of fabric worn over the shoe that extends to the ankle or knee

Herringbone: A V-shaped weave that resembles the skeletal structure of a herring fish

Jouy Print: An off-white or white background with a repeated pattern of a detailed scene

Knife Pleat: A sharp, narrow fold

Lettuce Hem: A wavy hemline created by stretching the fabric as it is sewn

Mandarin Collar: A small, fitted, upright collar

Marled: Yarn spun from one or more colors; often used to create knit sweaters

Minaudière: A small, ornamental evening bag; often adorned with jewels, metal trim, or other decorative items

Moire: A stiff, heavy fabric marked by slender, curving waves of ribboning that create a "watered" effect

Neats: Small socks with evenly-spaced designs and patterns

Ombré: A gradual change of one shade from dark to light; also called "degradé"

Paperbag Waist: A loose, pleated waistline that resembles a scrunched bag when gathered at the waist

Pinking: A notched, sawtooth edge applied to inner seams and on shoes as trim

Pointelle: An open knit pattern, typically in the shape of chevrons

Portrait Neckline: A wide, low-slung V-neck

Quarter: The section of a shoe that covers the heel

Raglan: A sleeve style with a continuous piece of fabric that continues to the neck with no shoulder seam

Sartorial: Relating to clothing or tailoring

Seersucker: Thin, puckered, cotton fabric

Surplice: A diagonal, overlapping V-shaped neckline that creates a wrap-like effect

Susurrus: The soft, whispering sound of rustling fabric

Trompe L'oeil: An artistic technique that uses real imagery made to appear three-dimensional

Vamp: The front section of the upper part of a shoe, which covers the toe and extends to the instep and laces (if applicable)

Vent: A split in a garment to allow for movement

Welt Pocket: A pocket set into a garment with a slit opening, instead of a patch or flap pocket

X-ray Fabrics: Sheer, translucent fabrics

Yoke: The fitted area of fabric along the front and back of the shoulders or at the top of a skirt

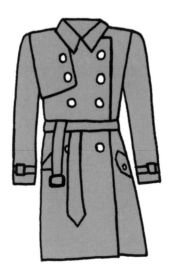

DRAW SOME SNAZZY SPECS

1. Start by drawing a cat-eye shape.

2. Draw the same shape again inside the first, but a little smaller.

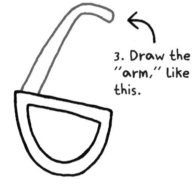

3. Draw the "arm," like this.

4. Add the "bridge."

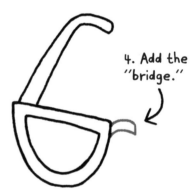

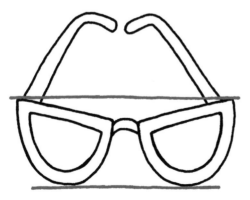

5. Repeat steps 1-3 on the other side. Don't worry about making both sides exactly the same. If you need to, you can draw pencil guidelines to line up the top and bottom of the frames.

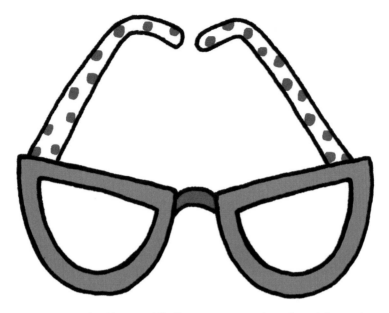

6. Decorate them with fun colors and embellishments, or try drawing specs in different shapes.

Voilà! Your sunglasses are finished.

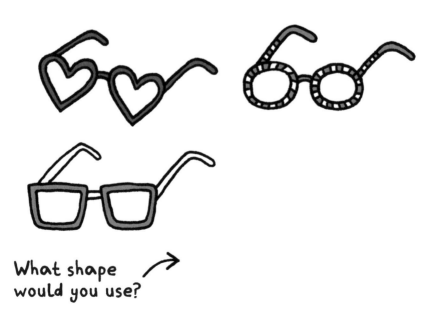

What shape would you use? →

Draw your snazzy glasses here!

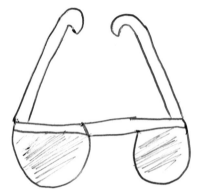

DRAW A CLASSIC PAIR OF JEANS

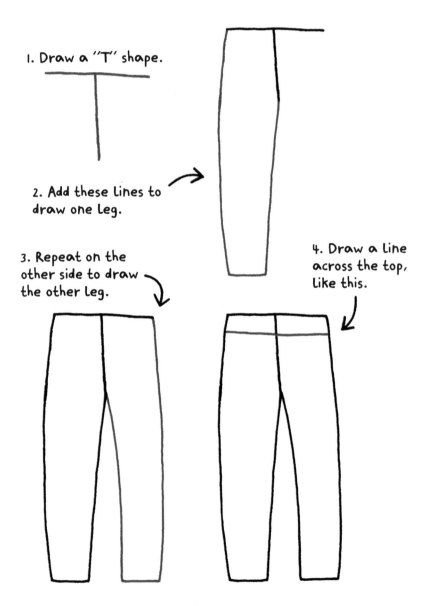

1. Draw a "T" shape.

2. Add these lines to draw one leg.

3. Repeat on the other side to draw the other leg.

4. Draw a line across the top, like this.

5. Draw belt loops and this shape for the fly.

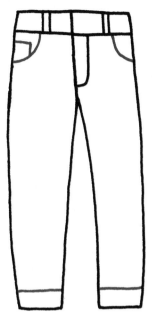

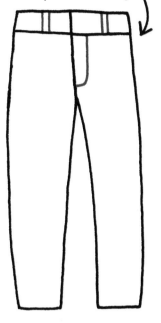

6. Add pockets and cuffs.

7. Add a button at the top.

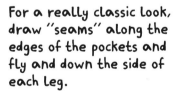

For a really classic look, draw "seams" along the edges of the pockets and fly and down the side of each leg.

That's it! Embellish your jeans with patches, rips, or patterns.

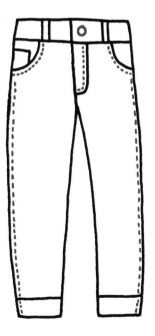

Doodle your jeans here!

DRAW A SUPER SIMPLE SHOE

1. Start by drawing a quadrilateral shape, like this.

2. Add a curve for the heel of the shoe.

3. Add another curve here.

4. Then draw this shape.

5. Draw a curved shape like this to form the toe.

6. Then add (you guessed it!) yet another curve at the front of the shoe.

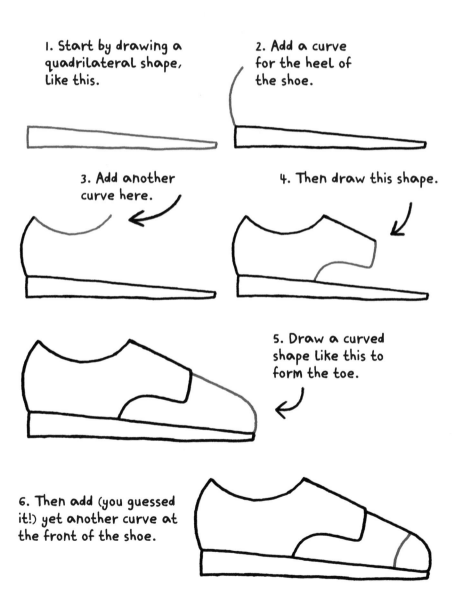

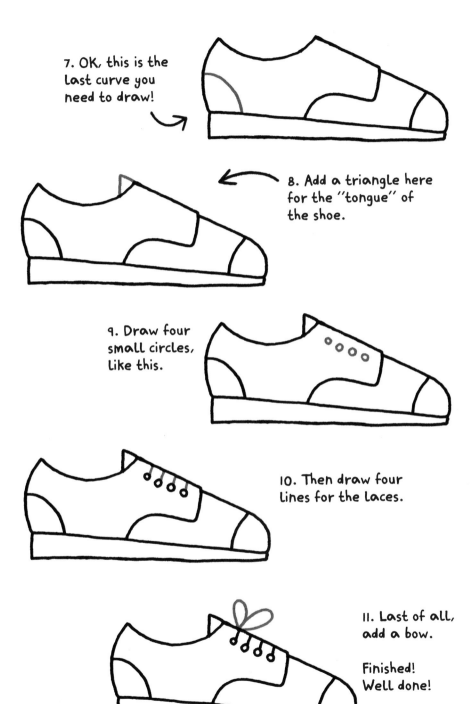

7. OK, this is the last curve you need to draw!

8. Add a triangle here for the "tongue" of the shoe.

9. Draw four small circles, like this.

10. Then draw four lines for the laces.

11. Last of all, add a bow.

Finished! Well done!

Doodle your super shoe here!

HATS, HATS, HATS!

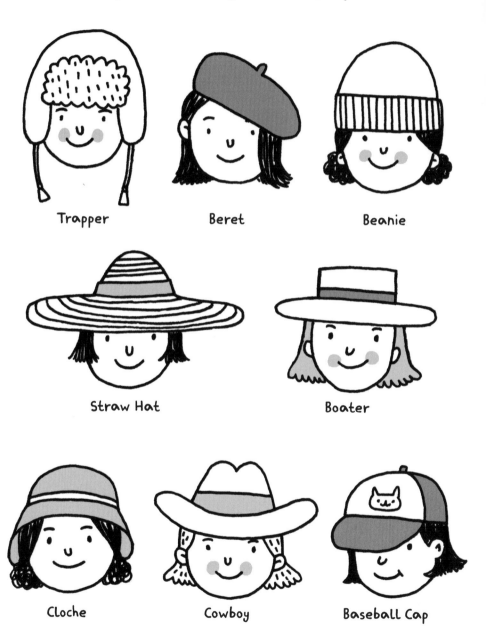

Trapper

Beret

Beanie

Straw Hat

Boater

Cloche

Cowboy

Baseball Cap

...and more hats!

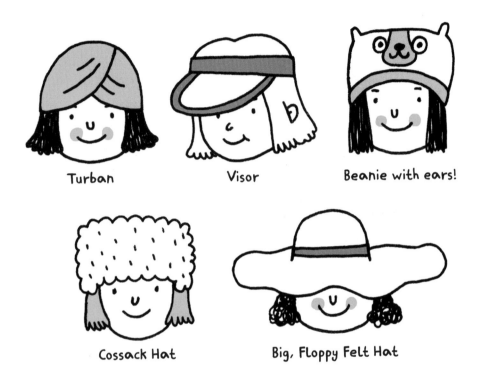

Turban

Visor

Beanie with ears!

Cossack Hat

Big, Floppy Felt Hat

Add a couple of hat designs of your own.

Beanies and baseball caps are cool and everything, but the biggest, craziest, most fun hats can be found at the races. Look up "Kentucky Derby" or "Ascot" for examples. Here are a few funny hat styles.

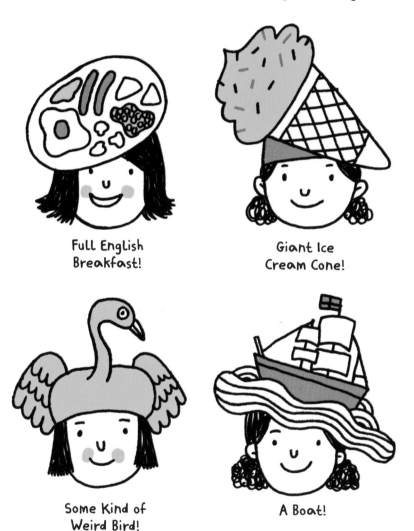

Full English
Breakfast!

Giant Ice
Cream Cone!

Some Kind of
Weird Bird!

A Boat!

Now over to you! Create a crazy, kooky hat for this fabulous fashionista to wear at the races.

AROUND THE WORLD IN HATS

Hats are important iconic markers of cultures all around the world. Here's just a glimpse of hats from every corner of the globe.

Austria
Tyrolean Hat: Also called a "Bavarian" or "Alpine" hat, a typical Tyrolean hat has crown that tapers to a point and is made of green felt

Canada
Tuque: A warm, knitted stocking cap; usually pointed

Chile
Chupalla: A traditional Chilean horseman's hat made of straw

Croatia
Šibenik Cap: A reddish-orange cap with a flat top and black ornaments

England
Deerstalker: A close-fitting hat with a visor at the front and back and earflaps that can be worn up or down (think Sherlock Holmes...)

France
Hennin: A towering cone- or heart-shaped hat worn in the fifteenth century; often adorned with a veil

India
Jaapi: A hat made of tightly woven bamboo or cane and palm leaf interwoven with cloth to create intricate designs

Jamaica
Rastacap: A tall, rounded, crocheted cap that is usually brightly colored

Kenya
Kofia: A brimless, cylindrical cap with a flat crown; "kofia" is Swahili for "hat"

Morocco
Fez: A round red hat with a flat top and no brim

Peru
Chullo: An Andean style of hat with earflaps made of alpaca, llama, or sheep's wool

Poland
Krakowiak: The traditional four-cornered hat of Poland's national folk costume; features a plume of peacock feather

SHIRTS & TOPS

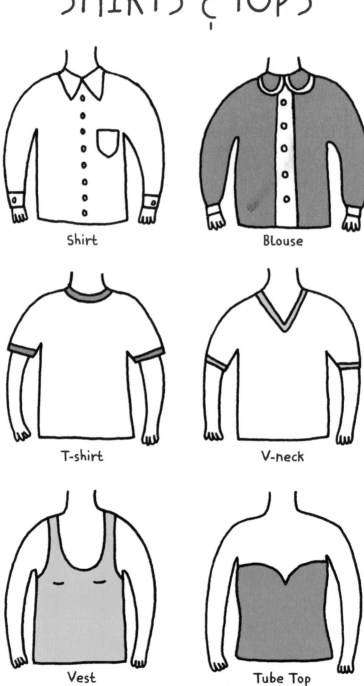

Shirt

Blouse

T-shirt

V-neck

Vest

Tube Top

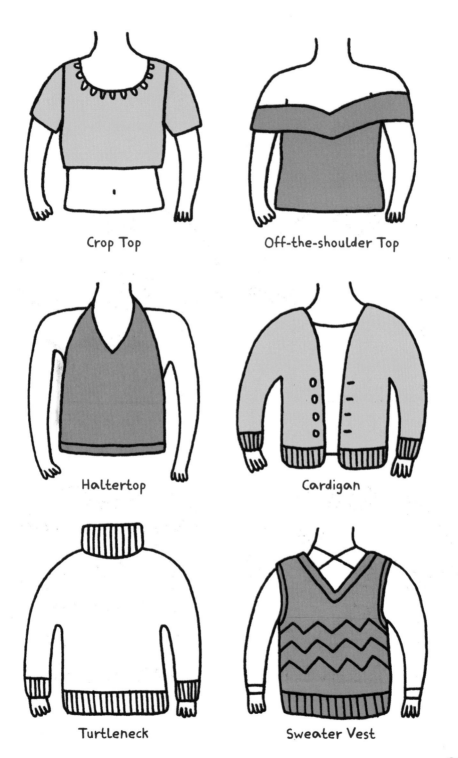

Crop Top

Off-the-shoulder Top

Haltertop

Cardigan

Turtleneck

Sweater Vest

DESIGN A T-SHIRT

Use the template to design a T-shirt that you'd love to wear. Here are a few ideas to get you started.

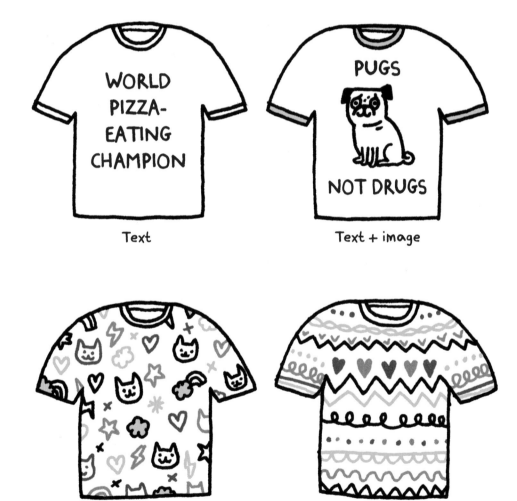

Text

Text + image

All-over pattern

Repeat pattern

THE WELL-STOCKED FASHIONISTA'S WARDROBE

When it comes to fashion, it's fun to explore, experiment, and break the rules! But there are some key staples that every fashionista should have. Here's a checklist for stocking your wardrobe with fashion must-haves!

Shoes
- ☐ Black pumps
- ☐ Nude pumps
- ☐ Brown boots
- ☐ Black boots
- ☐ Ballet flats
- ☐ Strappy sandals
- ☐ Flip-flops
- ☐ Casual tennies
- ☐ Seasonal footwear (rain boots, snow boots, etc.)

Accessories
- [] Sturdy everyday bag
- [] Belts (brown and black)
- [] Patterned scarf
- [] Statement necklace
- [] Pashmina
- [] Oversized sunglasses

Dresswear
- [] Little black dress
- [] Tailored blazer
- [] Pencil skirt
- [] White button-down shirt
- [] Camisoles (white, black, and nude)

Casual Wear
- [] Jeans (blue and black)
- [] Chambray shirt
- [] Basic tees
- [] Hoodie

Outerwear
- [] Trench coat
- [] Peacoat
- [] Leather jacket

What are your favorite go-to pieces?
Doodle them here!

COATS & JACKETS

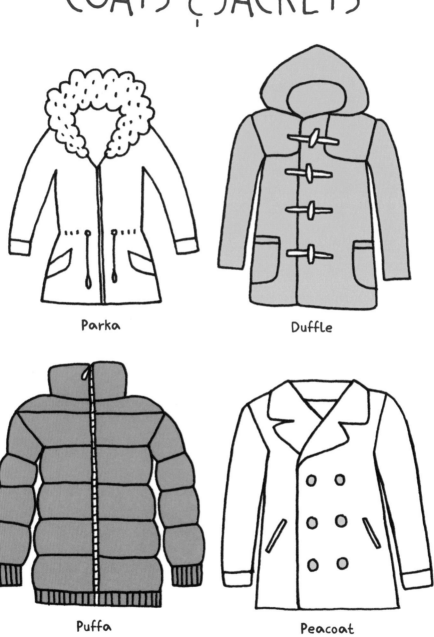

Parka

Duffle

Puffa

Peacoat

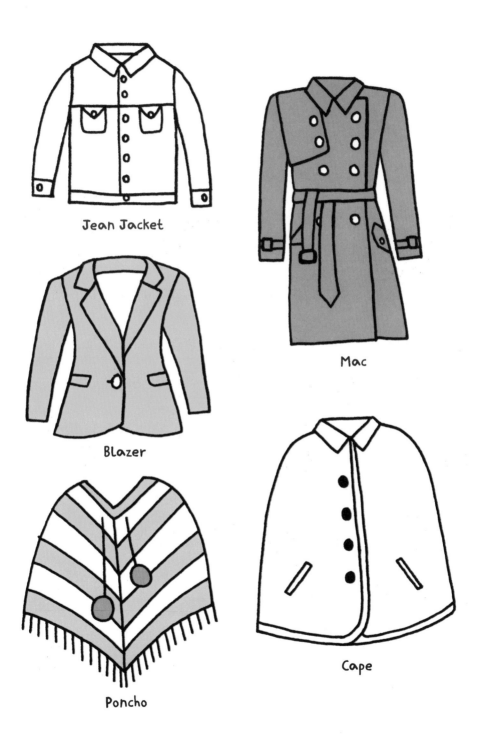

Jean Jacket

Mac

Blazer

Poncho

Cape

DESIGN A JAZZY JEAN JACKET

It's so much fun to decorate jean jackets with patches, buttons, and other fun stuff!

Here are a few bits and pieces to inspire you.

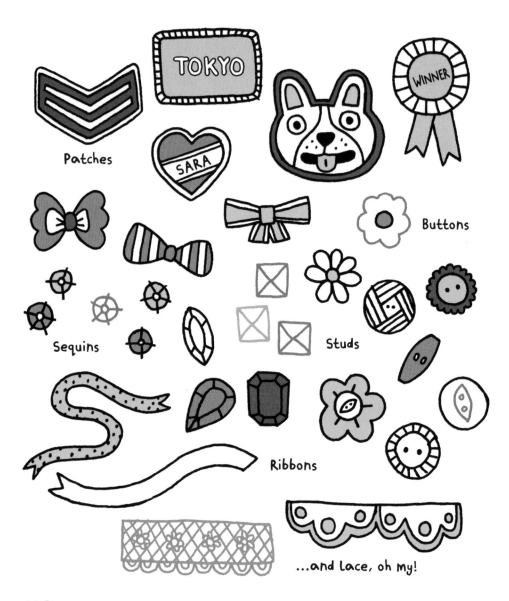

Patches

Buttons

Sequins

Studs

Ribbons

...and lace, oh my!

Here's a blank jean jacket
just begging to be adorned!

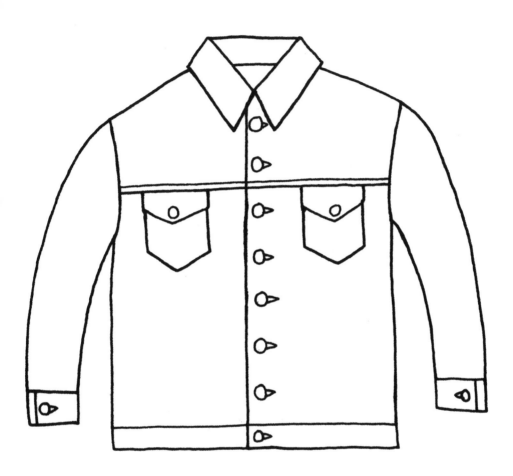

Doodle more cold-weather wear here...

A DAY IN THE LIFE

From sunup to sundown, a day in the life of a fashionista is full of style, flair, and panache!

6:30 AM Awaken after 8 hours of beauty sleep

6:45 AM Primp and preen in the powder room

7:30 AM Select an outfit, complete with perfectly chosen accessories

7:55 AM Post a selfie of the outfit on all social media networks

8 AM Morning commute, spent listening to a favorite fashion podcast

8:30 AM Arrive at the office, to numerous compliments about the carefully selected outfit

10:30 AM Mid-morning break to peruse the weekend's upcoming sales and plot a plan of attack

12 PM	Lunch at the outdoor mall, where people-watching and fashion-ogling opportunities abound
3 PM	Afternoon coffee break—just a drip coffee instead of the usual latte...gotta save those pennies for that new pair of shoes!
5 PM	Evening commute, spent brainstorming tomorrow's outfit
6 PM	Eat dinner while binge-watching fashion reality-T.V. shows
8 PM	Spend an hour online shopping
9 PM	Spend a half hour pinning pretty pictures to multiple fashion- and beauty-related Pinterest™ boards
9:30 PM	Time to strip away the day with a mini at-home facial
10 PM	In bed, browsing through the latest copy of *Vogue*®
10:30 PM	Fast asleep, ready to do it all again tomorrow...

MARVELOUS MAKEUP

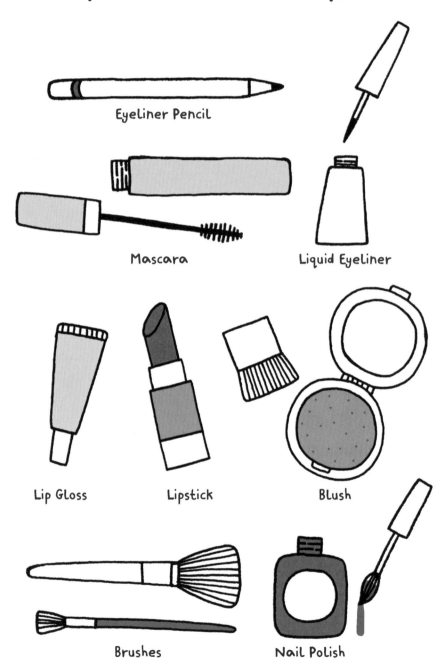

Eyeliner Pencil

Mascara

Liquid Eyeliner

Lip Gloss

Lipstick

Blush

Brushes

Nail Polish

FANTASTIC FRAGRANCES

Perfumes in pretty bottles...

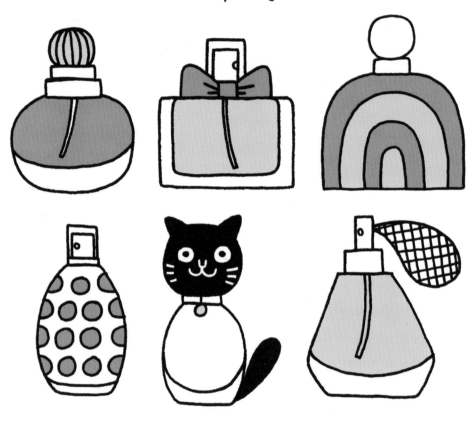

Doodle your own perfume bottle.

DOODLE NAILS

Add some pretty polish to these naked nails!

117

DOODLE EYE MAKEUP

Draw some fun and creative designs on these lids!

FASHION FUNNIES & FAUX PAS

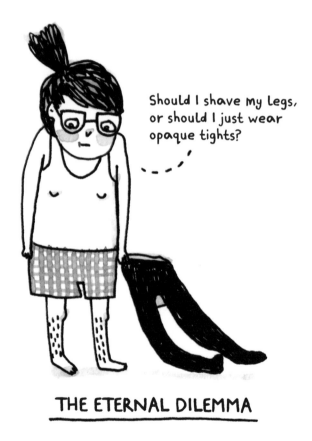

THE ETERNAL DILEMMA

FRIENDLY ADVICE FROM SOME SENSIBLE SHOES

Neither a
borrower nor
a lender be.

Look both ways before
crossing the road.

Never go out
with wet hair.

Always wear
clean underwear.

Take all your
makeup off
before going
to bed.

Don't play
with matches.

Never eat
yellow snow.

An apple a
day keeps the
doctor away.

Don't go to sleep
on an argument.

Money can't buy
you happiness.

Think before
you speak.

Don't talk to
strangers.

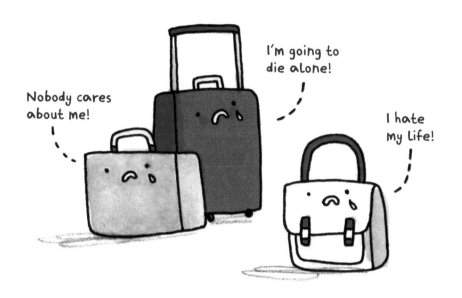

EMOTIONAL BAGGAGE

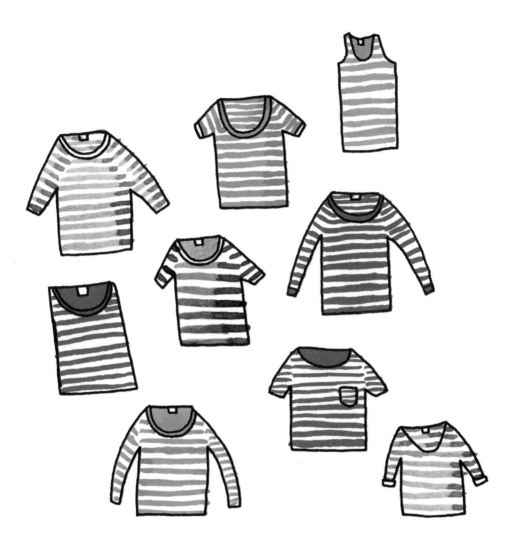

Hmm, what shall I wear today?

DOODLE DIARY

Use these pages to doodle all your favorite fashion finds and wish-list pieces!

125

ABOUT THE ILLUSTRATOR

Gemma Correll is a cartoonist, writer, illustrator, and all-around small person. She is the author of *A Cat's Life, A Pug's Guide to Etiquette,* and *It's a Punderful Life,* among others. Her illustration clients include Hallmark, *The New York Times,* Oxford University Press, Knock Knock, Chronicle Books, and *The Observer.*
Visit www.gemmacorrell.com to see more of Gemma's work.